A Dog's
WORLD

First published in 2015 by New Holland Publishers Pty Ltd

London · Sydney · Auckland
The Chandlery Unit 9, 50 Westminster Bridge Road, London SE1 7QY, United Kingdom
1/66 Gibbes Street Chatswood NSW 2067 Australia
218 Lake Road Northcote Auckland New Zealand

www.newhollandpublishers.com

A record of this book is held at the British Library and the National Library of Australia.

ISBN 9781742576770

Managing Director: Fiona Schultz
Publisher: Diane Ward
Project Editor: Angela Sutherland
Designer: Andrew Quinlan
Production Director: Olga Dementiev
Printer: Toppan Leefung Printing Ltd

10 9 8 7 6 5 4 3 2 1

Keep up with New Holland Publishers on Facebook
www.facebook.com/NewHollandPublishers

A Dog's WORLD

By Asia Upward

NEW HOLLAND

Contents

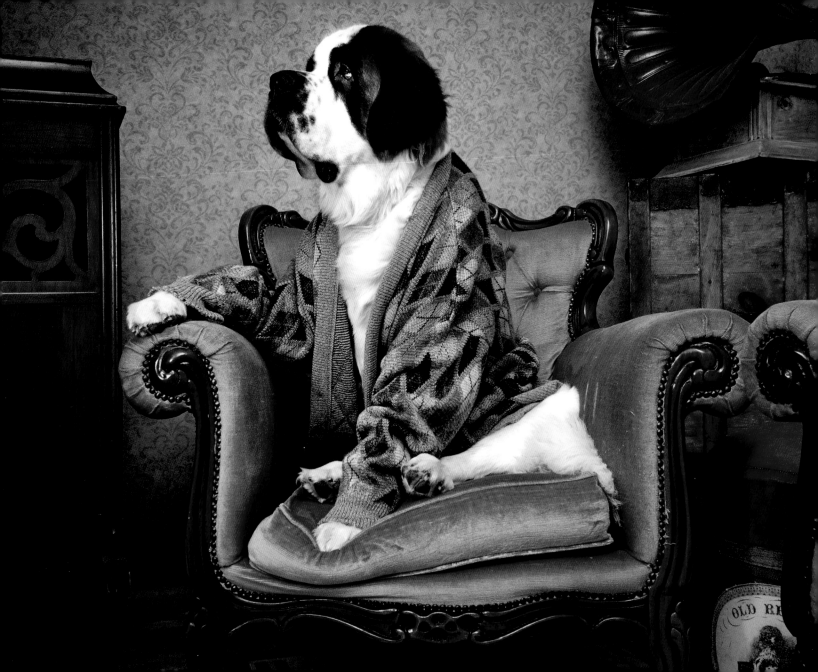

Dedicated to all the dogs of the world
and to the people who love them.

Treats

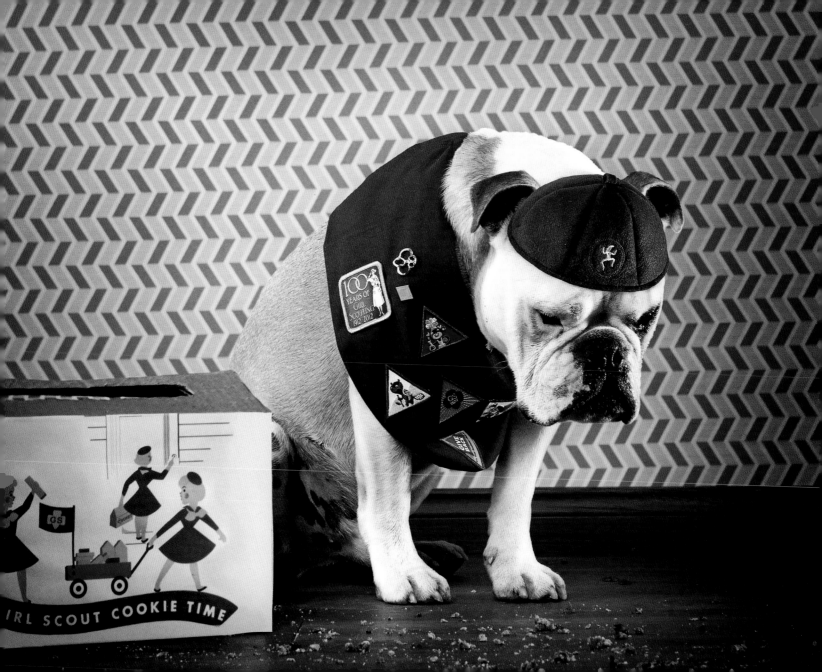

GIRL SCOUT COOKIE TIME

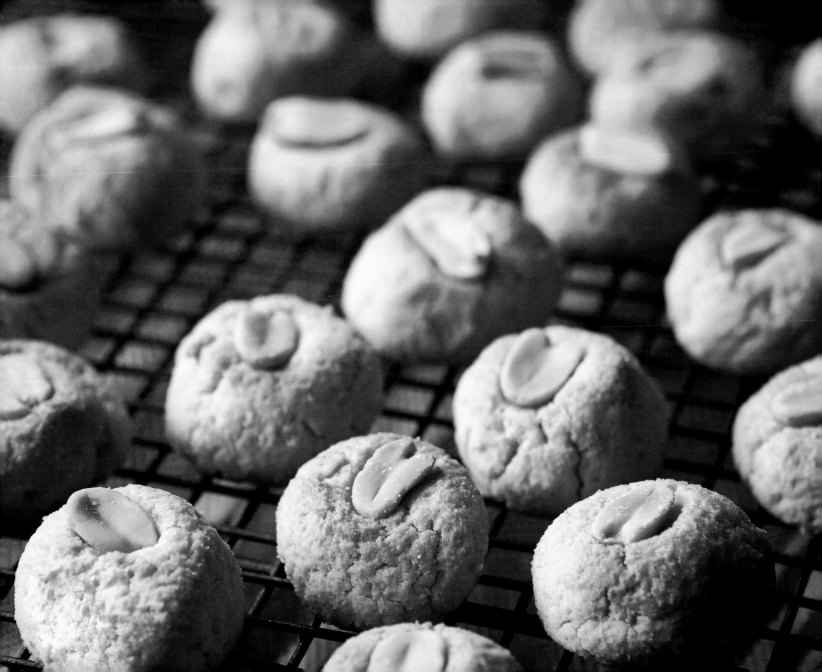

Peanut Butter Crunchies

Ingredients

1½ cups water

½ cup sunflower oil

2 eggs

3 tbsp peanut butter

2 tsp vanilla

1 cup coconut flour

1 cup rice flour

½ cup semolina

½ cup oats

Directions

Blend wet ingredients together.

Mix dry ingredients together.

Combine both wet and dry mixtures.

Roll out and shape into balls.

Place onto a non-stick or lightly greased baking tray.

Cook for 20 minutes at 180°C/350°F.

Turn off the oven and cool the biscuits in the oven until crisp and hard.

Store in an airtight container for up to 5 days.

Chicken Liver Chumps

Ingredients

1½ cups rice flour

3 tbsp sunflower oil

1 cup semolina

½ cup oat bran

1 egg, lightly beaten

¾ cup chicken broth

2 tsp fresh parsley

1 cup cooked chicken liver, chopped

Directions

Combine flour and semolina.

In separate bowl beat egg with oil and parsley.

Add the dry ingredients to the bowl a little at a time, while stirring.

Add chicken broth, a little at a time and stir well.

Fold in chicken liver. Dough will be firm.

Knead briefly to mix thoroughly.

Roll out and cut into shapes or mould with hands.

Place on greased baking tray or baking paper.

Bake at 180°C/350°F for 30 minutes or until firm.

Store in refrigerator for up to 3 days.

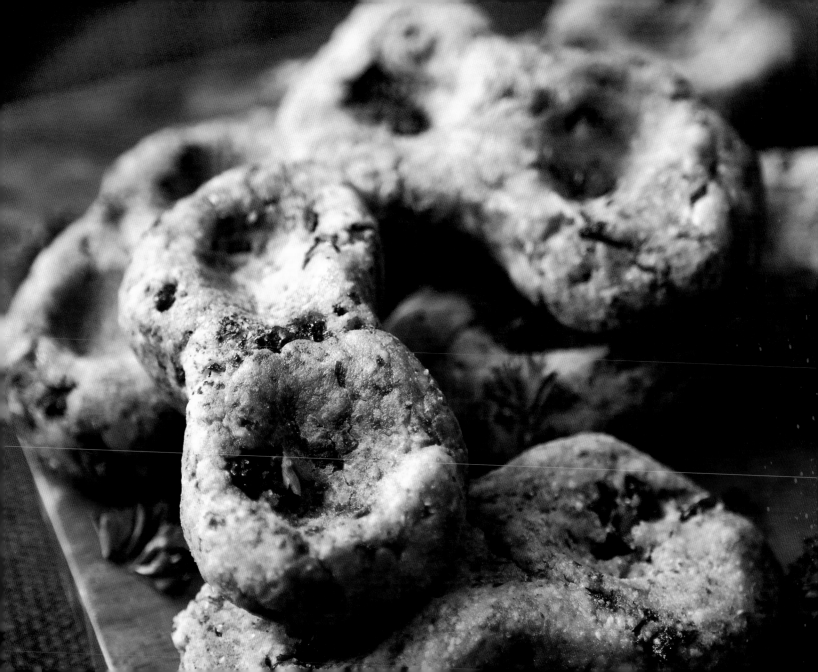

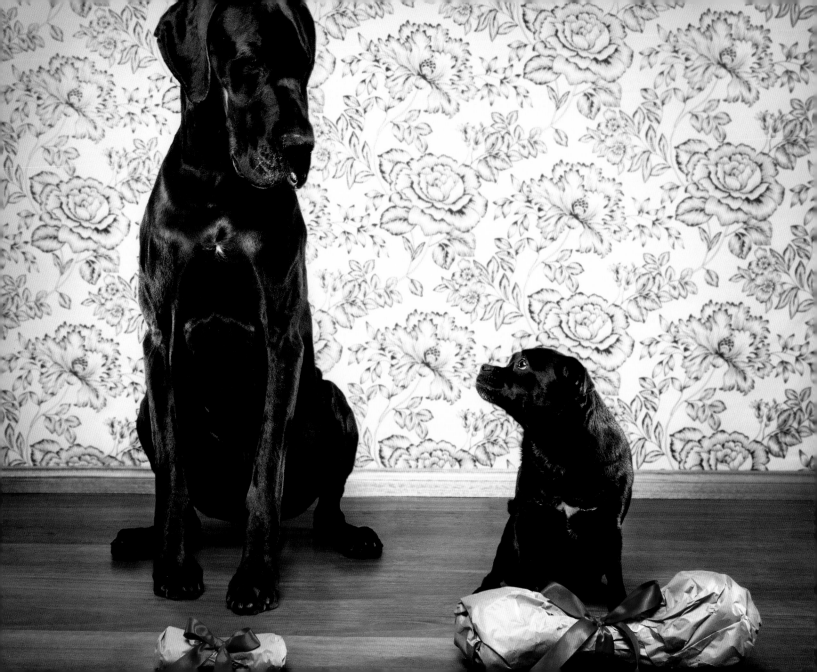

Bone Biccies

Ingredients

1 cup couscous

1½ cups hot water

1 cup grated cheese

1 egg (beaten)

1 cup wheat germ

¼ cup sunflower oil

½ cup powdered milk

1 cup of semolina

2 cups rice flour

Directions

In a large bowl pour hot water over couscous and sunflower oil.

Let cool.

Stir in powdered milk and egg.

Add semolina, wheat germ and cheese. Mix well.

Add flour, a bit at a time, mixing well.

Knead for 3 minutes, adding more flour if necessary to make a stiff dough.

Pat or roll dough to 1cm/½ in. thickness.

Cut into bone shaped biscuits and place on a greased baking sheet.

Bake for 1 hour at 170°C/340°F.

Store in an airtight container for up to 5 days.

Chirkey

Ingredients

2–4 chicken breasts

Directions

Preheat the oven to 180°C/350°F.

Slice each chicken breast into strips.

Line a baking tray with a sheet of baking paper.

Lay the chicken strips on the paper.

Bake for around 2 hours. The strip should be dry and hard.

Allow the strips to cool before serving.

Store in an airtight container for up to 2 weeks.

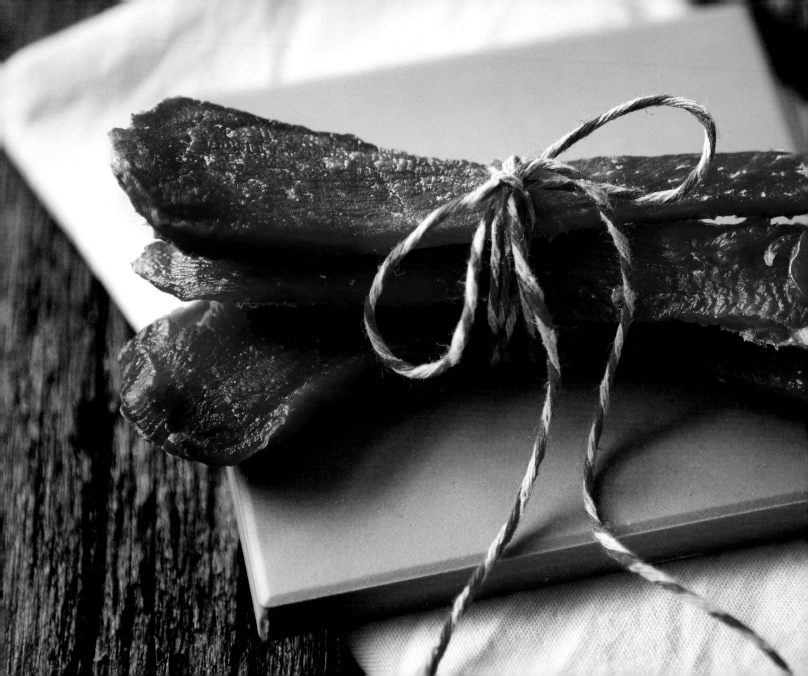

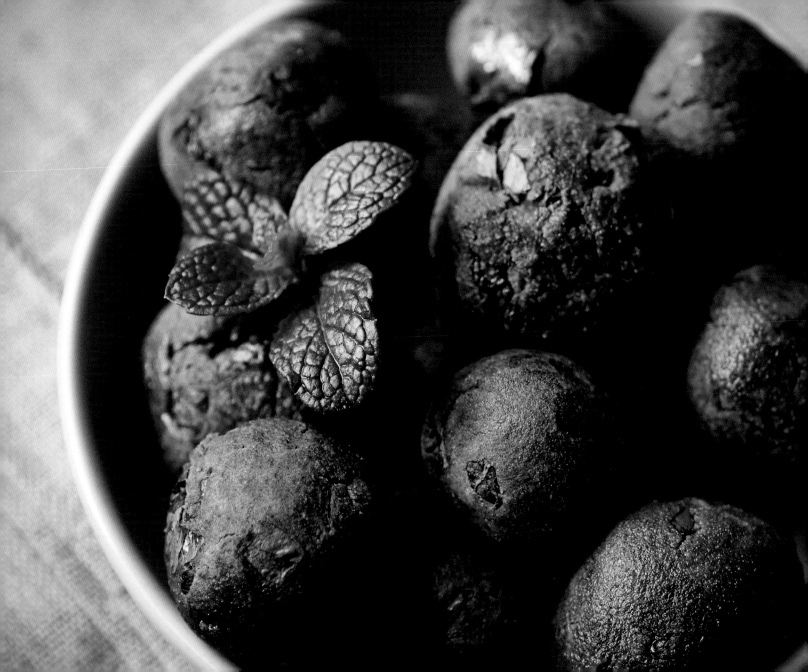

Fresh Mint Balls

Helps fight bad breath

Ingredients

2 cups rice flour

1 tbsp activated charcoal (pharmacy)

3 tbsp sunflower oil

1 egg

¾ cup chopped fresh mint

¼ cup chopped fresh parsley

⅔ cup lactose free milk

Directions

Preheat oven to 200°C/390°F.

Line a baking tray with baking paper.

Combine flour and charcoal.

Add all other ingredients.

Roll mixture into small bite size balls and place on the baking paper.

Bake for 20 minutes or until hard.

Store in airtight container for up to a week.

Top Dog Treats

Ingredients

400g/14 oz ground meat (chicken, turkey, or beef)

1 carrot, finely grated

½ cup ground flaxseed

1 egg (beaten)

2 tbsp tinned crushed tomatoes

½ cup low fat grated cheese

Directions

Preheat oven to 200°C/390°F.

Mix all ingredients together, you can use a food processor.

Roll into small balls and place on a greased baking tray.

Bake until brown and firm—about 15 minutes.

Cool in the oven.

Store in the fridge in an airtight container for up to 3 days.

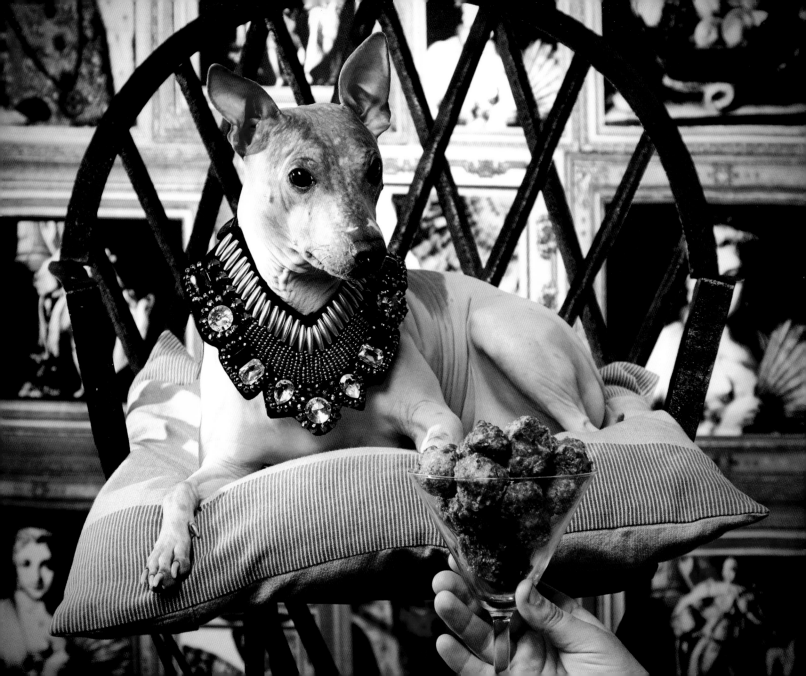

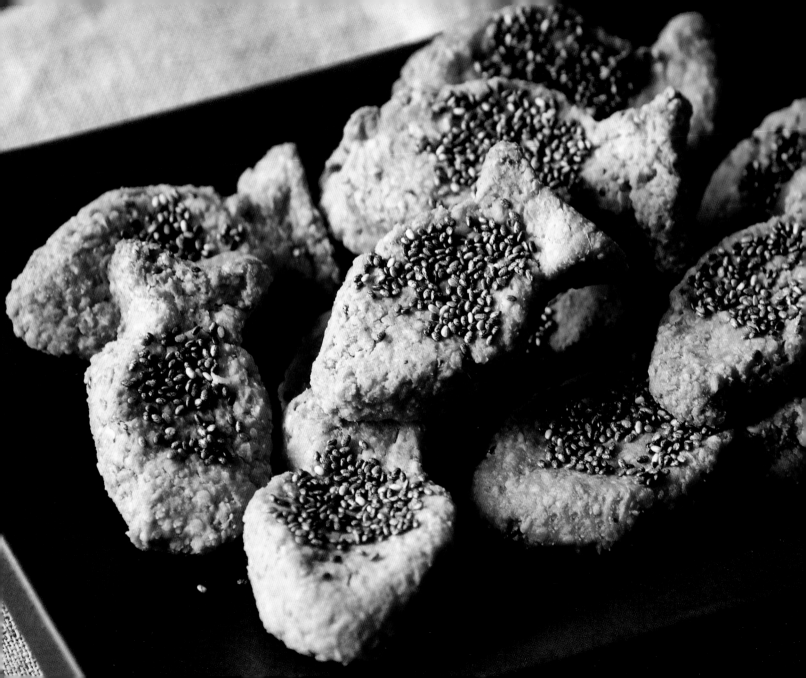

Tuna Treats

Ingredients

½ cup oat flour (put rolled oats in a food processor until it is a flour consistency)

1 cup semolina

½ cup wheat germ

½ tsp baking powder

185g/6 oz tin tuna in oil (add the oil to the mixture)

⅓ cup water

Chia seeds for garnish

Directions

Mix all ingredients together, except for the chia seeds.

Line a baking tray with baking paper.

Spoon mixture onto the baking paper in what ever shapes you like.

Cook at 170°C/340°F for 25 minutes, or until golden brown.

Store in the fridge in an airtight container for up to 4 days.

Pumpkin Pie Soft Serve

Ingredients

700g/1 lb 9 oz fresh pumpkin puree

½ cup 100% pure maple syrup

1½ tsp ground cinnamon

½ tsp of ground cloves

1 tsp vanilla extract

½ tsp ginger

2 cups plain low fat yogurt

Sesame seed garnish (optional)

Directions

Steam the pumpkin and add it to a food processor with the maple syrup, cinnamon, cloves, vanilla and ginger.

Blend until smooth.

Make sure the pumpkin has cooled to room temperature and add the yoghurt.

Blend again for 1 minute.

Add the mixture to an ice cream maker and follow the instructions for that particular machine.

It is best to eat fresh.

You can halve the ingredients if you only have 1 small dog or you can treat yourself to the left overs.

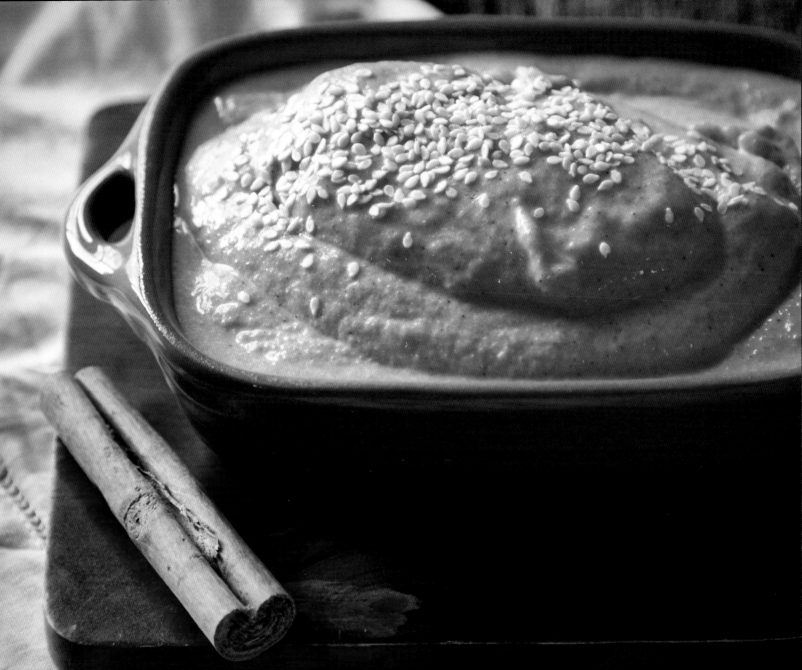

Beet and Beef Treats

Ingredients

2 beetroots/beets

1 sweet potato

500g/17 oz mince meat

2 cups dry milk powder

1 cup water

Directions

Steam beetroot/beets and sweet potato until soft.

Blend all ingredients together.

Drop the mixture onto a baking sheet in large spoonfuls.

Bake for 30 minutes at 200°C/390°F.

Allow the treats to cool completely.

These create a soft biscuit, which are ideal for those that need something a little less hard on the mouth.

Store in an airtight container in the fridge for up to 3 days.

Icy Pole Bones

Ingredients

1½ cups natural low fat yoghurt

1 banana

2 tbsp peanut butter

1 tbsp honey

Directions

Mash the banana thoroughly.

Add all the ingredients into a food processor or blender and mix until smooth.

Place mixture into ice cube trays and freeze.

Once frozen they are ready to serve.

Store in freezer in a plastic container.

Summer Suckers

Ingredients

Hot water to fill half of container

1 tsp beef powder

2 rashes bacon, cooked and cut into pieces

2 tbsp peanut butter

2 tbsp peanuts, unsalted

Directions

Half-fill an ice cream container with hot water.

Dissolve beef powder and peanut butter in the hot water.

Fry bacon bits.

Once bacon is nearly cooked, add a handful of peanuts and continue to fry.

Remove from heat and add to ice cream container.

Put in freezer until frozen solid.

To remove the ice cube from the container run the bottom under warm water until it comes loose.

Put in a bowl and serve.

Main
Course

Canine Classic Frittata

Ingredients

6 eggs

4 tbsp cottage cheese

½ cup lactose free milk

125g/4 oz bacon

1 carrot, finely sliced

½ sweet potato, sliced

1 leaf silver beat, finely chopped

1 tsp sunflower oil

Directions

Preheat oven to 200°C/390°F.

Fry bacon.

Steam sweet potato and carrots, and mix them in sunflower oil.

Blend eggs, cottage cheese and milk.

Line ingredients in a baking dish and pour egg mixture over the top.

Bake for 30 minutes or until golden on top.

Let cool and serve at room temperature.

Store in fridge in airtight container for up to 3 days.

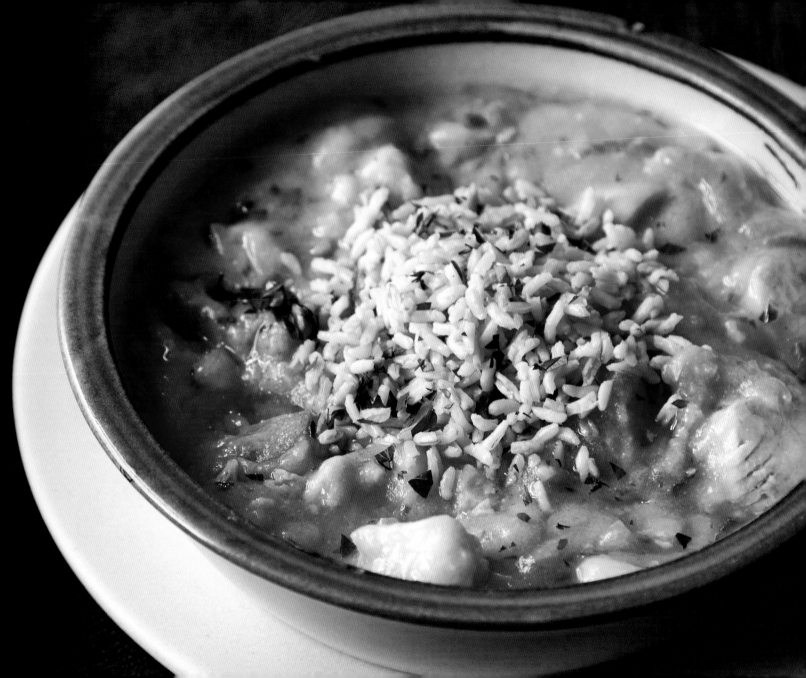

New Orleans Doggie Gumbo

Ingredients

¼ cup sunflower oil

2 small okra, caps and tips removed, or 3 tsp cornflour

1 cup rice flour

3 rashes bacon

1 cup celery, chopped

3 carrots, diced

1 tin of diced tomatoes

3 cups water

2 cups fish stock

2 tsp parsley, finely chopped

500g/17 oz white fish flesh, cut into chunks (remove all bones)

500g/17 oz salmon fillet, cut into chunks (remove all bones)

4 cups cooked brown rice

Directions

In a saucepan, combine the rice flour and the oil, stir over low heat until golden. Do not burn. Put to the side.

In a large pot with a drizzle of oil, add celery, carrots and bacon.

Cook until soft.

Add stock, parsley, tomatoes and flour mix.

Stir until thickened.

Add fish and okra/cornflour.

Bring to boil and then simmer on a low heat until cooked through.

Serve over brown rice.

Store extras in fridge for up to 3 days or freeze in an airtight container.

Winter Warmer Soup

Ingredients

500g/17 oz beef hearts

1 cup barley

3 cups vegetables such as: carrots, baby cabbage and zucchini/courgette

1 tsp beef broth powder

½ tsp turmeric

Fresh rosemary

½ litre/17 fl oz water

1 tbsp low fat natural yoghurt

Parsley, finely chopped

Directions

Chop and brown the beef hearts.

Put the browned meat, vegetables, barley, broth powder, turmeric, rosemary and water into a large pot and bring to the boil.

Reduce the heat once it has started boiling and simmer covered for 30 minutes.

Serve at room temperature over brown rice.

Garnish with yoghurt and parsley.

Store in the fridge for up to 3 days or freeze any extras.

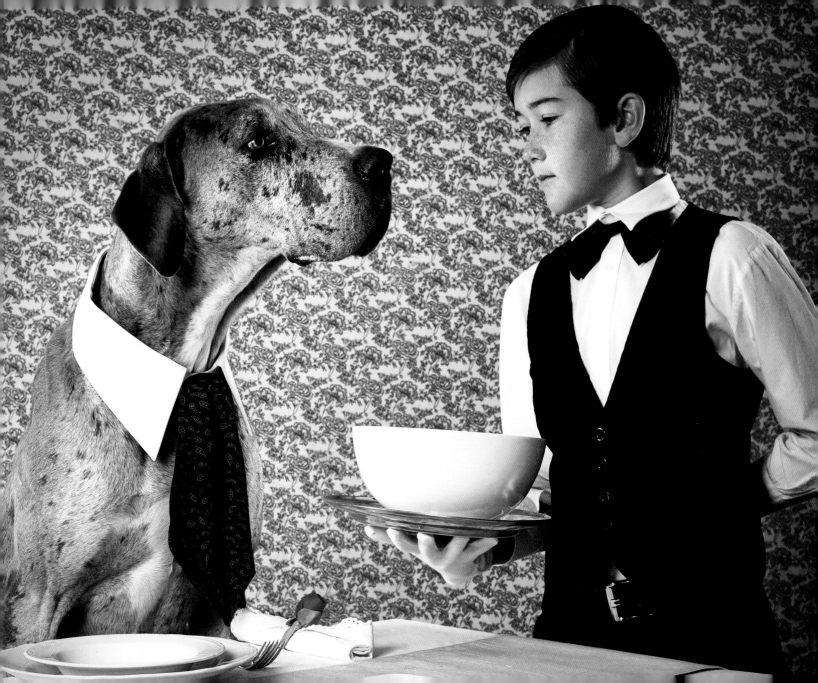

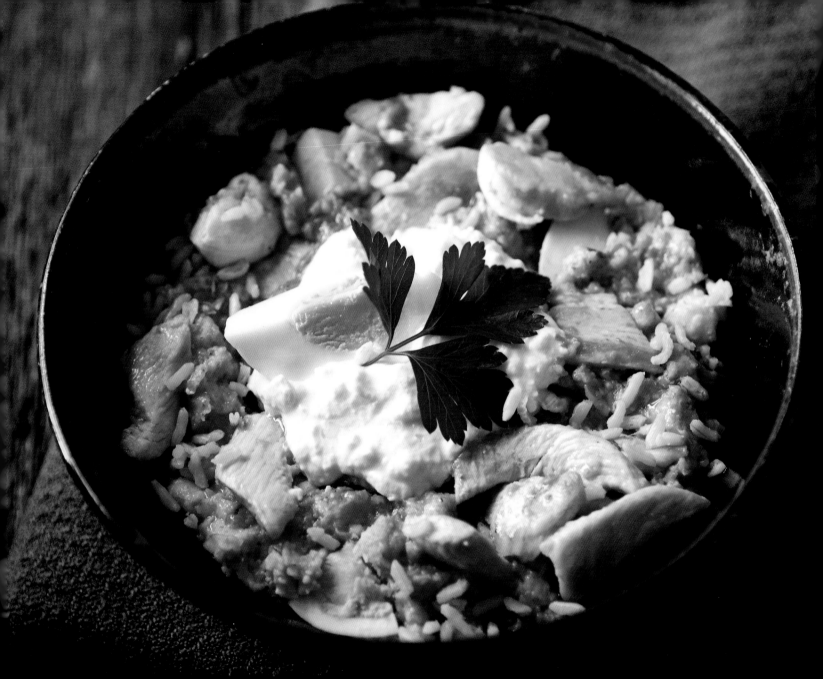

Doggie Chow

Ingredients

½ cup chicken breast, finely chopped

½ tbsp sunflower oil

¼ cup cooked brown rice or cooked oats

¼ cup fat-free cottage cheese

1 hard-boiled egg, chopped

¼ cup pureed vegetables (spinach, carrots, sweet potato, peas)

Directions

In a medium pan, brown the chicken in sunflower oil.

Once chicken is cooked add rice/oats, vegetables, eggs, and cottage cheese.

Mix well.

Let cool to room temperature.

Store extras in fridge in an airtight container for up to 3 days.

Canine Beef and Rice

Ingredients

2 cups cooked brown rice

⅔ cup lean chunky beef

2 tsp flaxseed oil (optional)

½ cup vegetables (carrots, green beans, broccoli), finely chopped

Directions

Mix all ingredients together.

If you use chunks of beef you can serve it raw. If you use minced beef, it is best to cook first.

Serve at room temperature.

Store extras in fridge in an airtight container for up to 3 days.

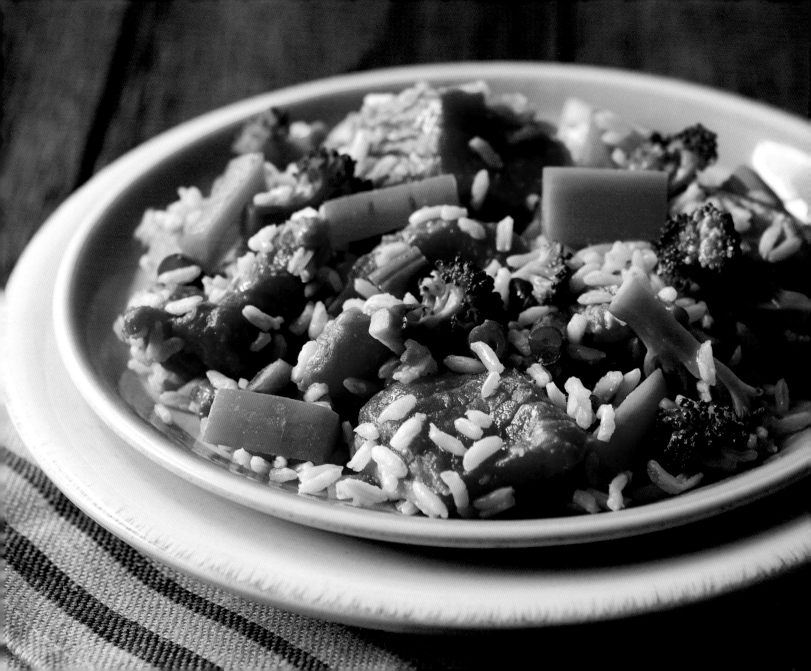

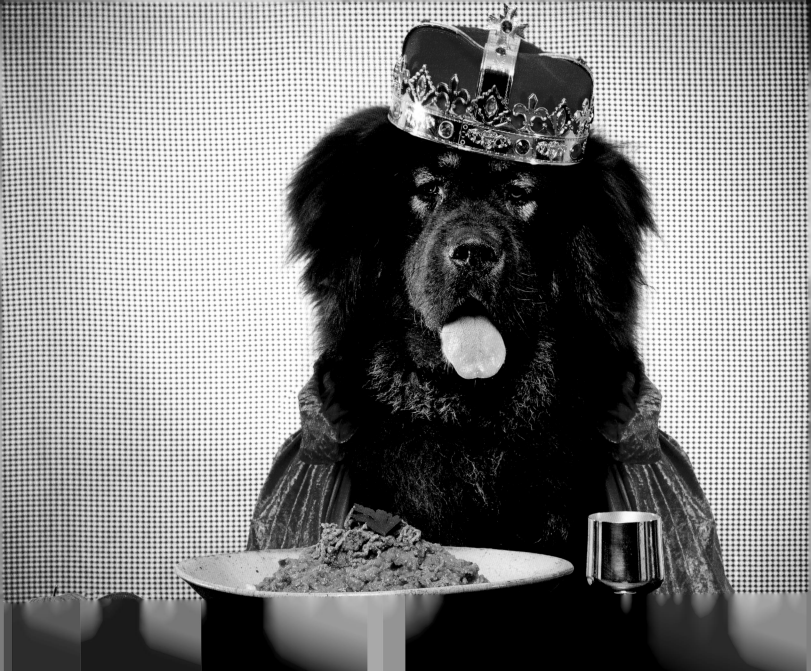

A Meal Fit For a King

Ingredients

1kg/2 lb 3 oz minced beef

750g/1 lb 10 oz or 3 packets of 90 second brown rice

1 tin of chickpeas

1 mashed sweet potatoes

1 cup of cooked mashed pumpkin

Pureed vegetables (2 carrot, 1 cup green beans, ½ bunch silverbeet)

3 tbsp sunflower oil

Directions

Brown meat in sunflower oil.

In a bowl mix, all the ingredients together.

Let cool and serve.

Store extras in fridge in an airtight container for up to 3 days.

Doggie Beef Stew

Ingredients

500g/17 oz stewing beef

1 sweet potato

3 medium carrots

2 celery sticks

1 tsp beef stock powder

4 cups of water

2 tbsp sunflower oil

2 tbsp fibre mix (ground, from health food section)

Directions

Chop all vegetables into small bite size pieces.

Brown the meat with sunflower oil in a large pot.

Once the beef has browned on all sides, add beef stock and water, and bring to boil.

Cover with a lid and let simmer for 10 minutes.

Add the vegetables to the pot. Replace the lid, leaving a small gap for steam to escape, and let simmer for 1 hour.

Remove the pan from the heat and stir through fibre mix.

Serve at room temperature.

Store extras in fridge for up to 3 days or freezer in an airtight container.

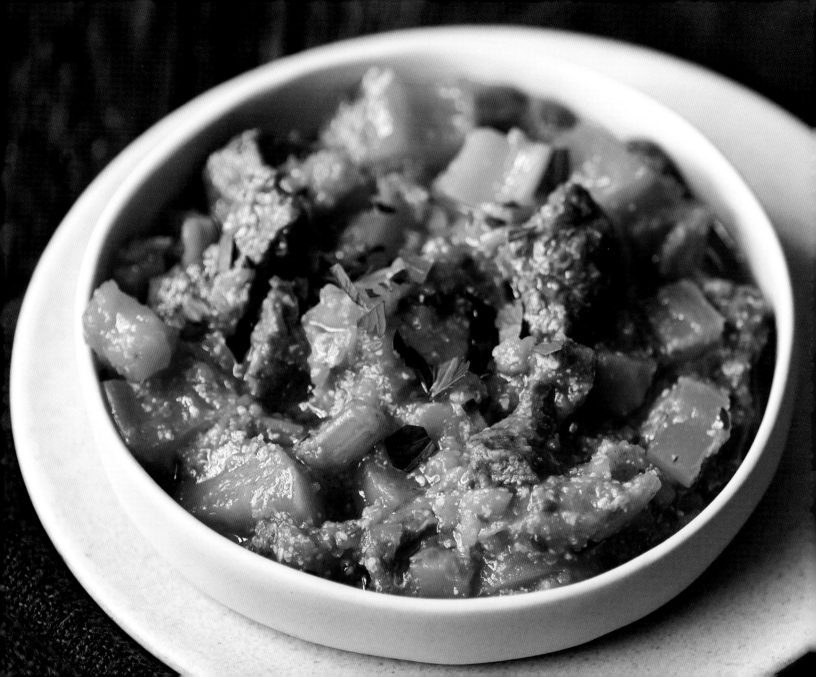

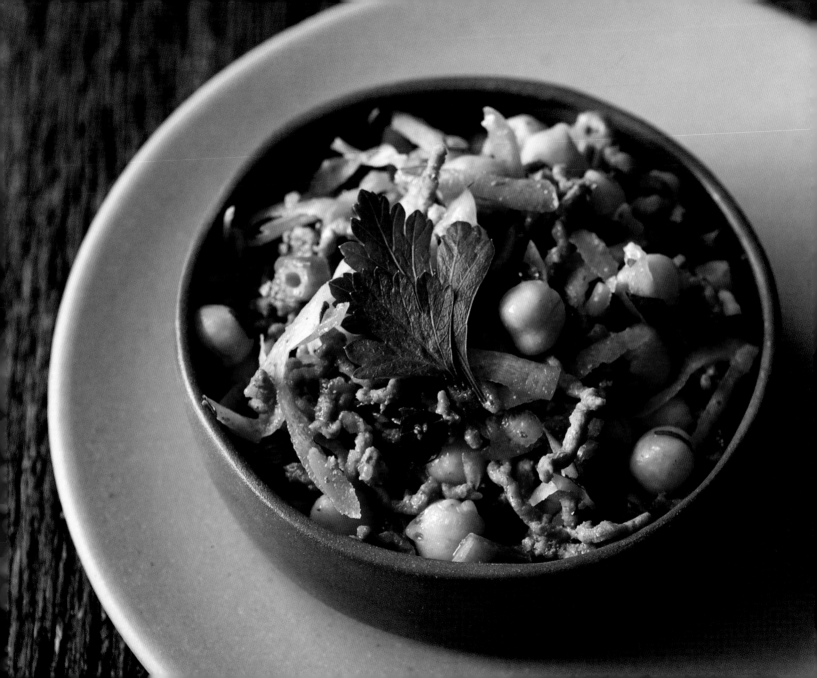

Chickpea Salad

Ingredients

2 tins chickpeas

1 grated zucchini/courgette

1 grated carrot

1 cup green beans,
finely chopped

½ bunch parsley,
finely chopped

1kg/2 lb 3 oz ground beef

1 tbsp sunflower oil

Directions

Cook ground beef in sunflower oil.

Cut green beans and steam in the microwave for
1 minute.

When everything has cooled, mix all ingredients
together.

*Keep leftovers in fridge in airtight container for up
to 3 days.*

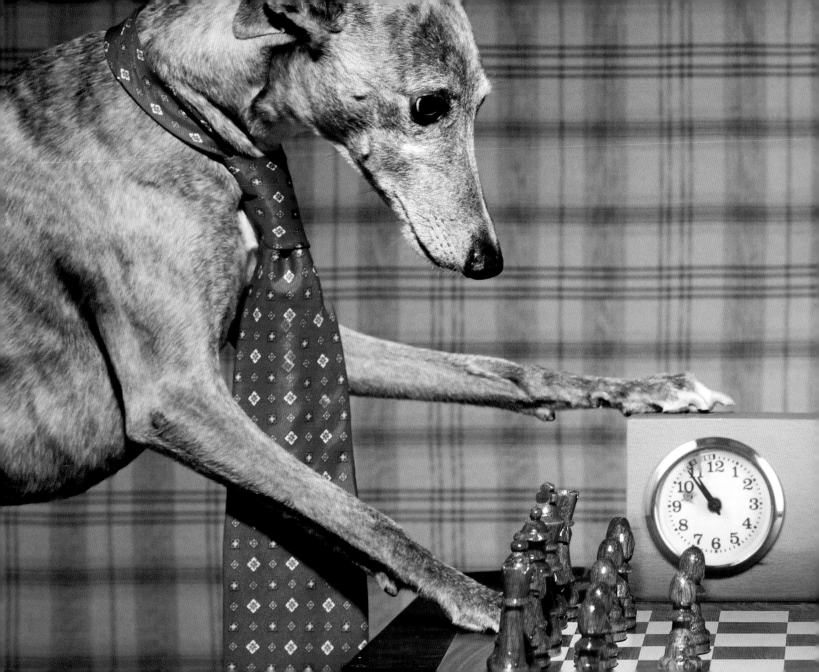

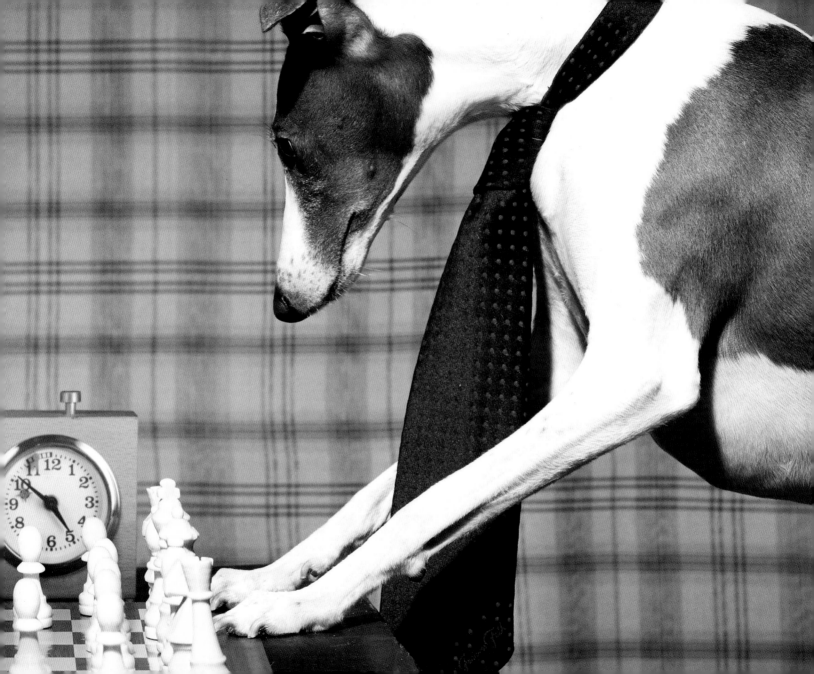

Meatballs and Pasta

Ingredients

2 cups extra-lean ground beef

½ cup oats

1 cup vegetables (sweet potato, broccoli, carrots), pureed

2 tbsp cottage cheese

1 tbsp ground flaxseed

Wholegrain pasta shells

1 can crushed tomatoes (no salt)

1 tbsp sunflower oil

Directions

Heat oven to 180°C/350°F.

Mix ground beef, pureed vegetables, cottage cheese, oats, flaxseed and a drizzle of sunflower oil.

Roll into balls.

Place balls onto a greased tin.

Add a tin of tomatoes over the top.

Cook for 40 minutes or until cooked through.

Cook pasta.

Let everything cool to room temperature.

Put in bowl and serve.

Store extras in fridge in an airtight container for up to 3 days
.

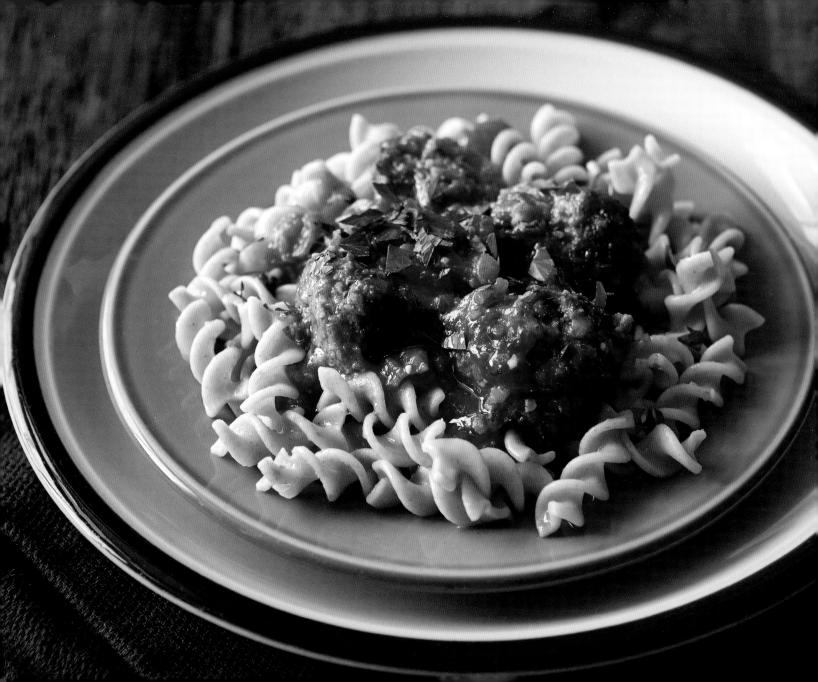

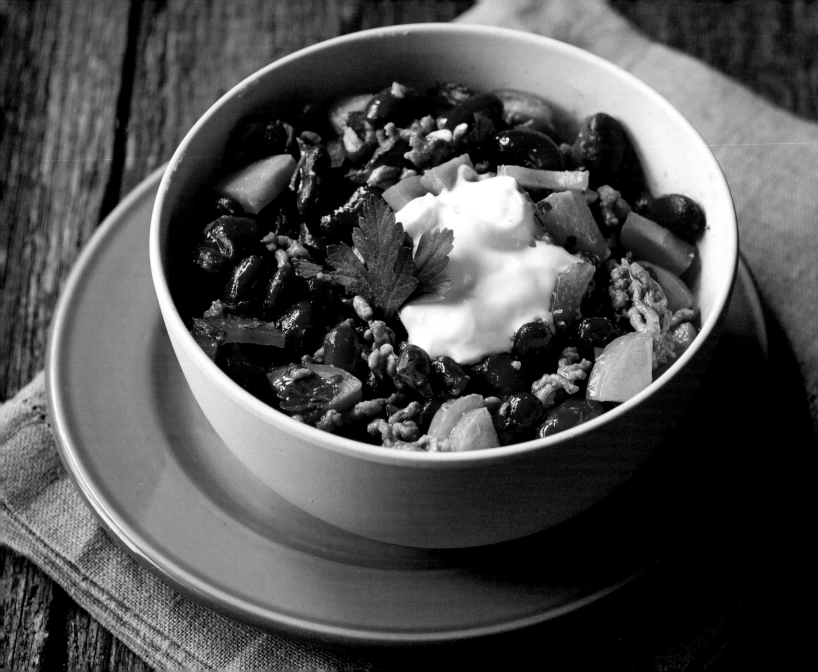

A Taste of Mexico

Ingredients

2 tins red kidney beans

1kg/2 lb 3 oz lean ground minced meat

Sunflower oil to cook

2 carrots, finely chopped

2 celery sticks, finely chopped

Fresh parsley, finely chopped

1 tbsp natural low-fat yoghurt

Directions

Cook mince with sunflower oil and leave to cool.

Drain tins of beans.

Finely chop the carrots, celery and parsley.

Combine all ingredients.

Top with yoghurt and serve.

Make sure mince meat has cooled to room temperature before serving.

Store in airtight container in fridge for up to 3 days.

Pulled Pork Burger

Ingredients

1 x 2–2.2kg/4½–5 lb boneless or bone-in pork shoulder (also known as pork butt), twine or netting removed

Chicken stock

1 tsp cinnamon

½ cabbage

1 carrot

1 packet of 90 second brown rice

2 tbsp chia seeds

1 tbsp gluten-free flour (I use rice flour)

1 large egg, lightly beaten

Sunflower oil for frying

Directions

Pulled Pork
In an oven proof pot, combine pork shoulder, stock and cinnamon. Cook at 170°C/340°F for 6 hours.

Cabbage and carrot salad
Finely chop the cabbage and carrot, and mix together. In a pot, boil the mixture until it becomes slightly soft.

Rice Patty buns
Mix together rice, chia seeds, flour and egg. Line 2 small bowls with cling film.

Split mixture evenly between the 2 bowls. Pack mixture tightly into patties leave in the fridge for 30 minutes, or until you are ready to use it.

In a heavy based fry pan, heat the sunflower oil. Carefully remove your patty buns from the cling wrap and add to the pan.

Cook the patties until golden brown and let them cool on paper towels to drain excess oil.

Let everything cool and add your burger filling.

Store extras in fridge in an airtight container for up to 3 days.

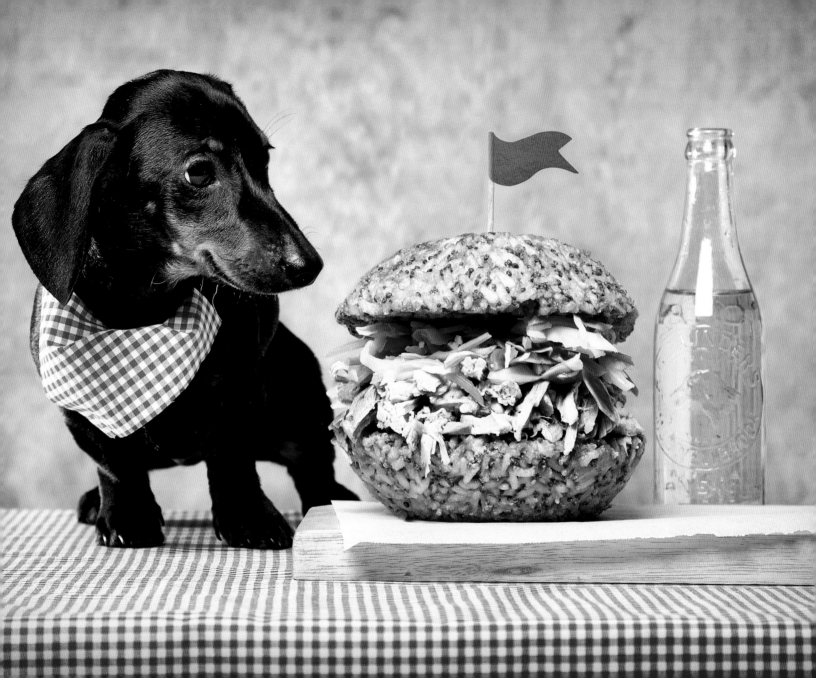

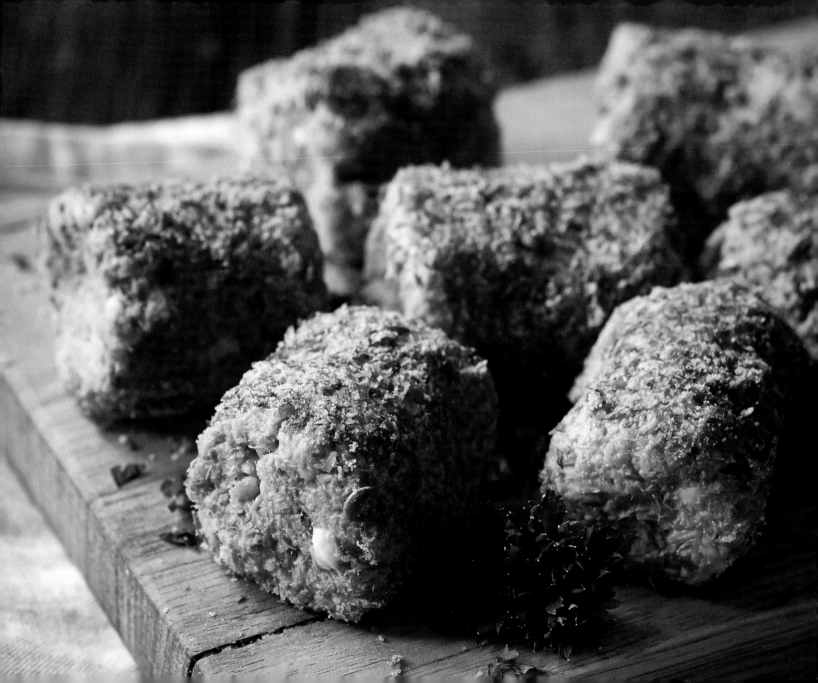

Fish Fingers

Ingredients

1 x 415g/14 oz tin salmon in water

1 x 125g/4 oz tin sardines in water

3 tbsp low-fat cottage cheese

2 tsp turmeric

2 tsp flaxseed oil (optional)

½ cup gentle fibre (packed mix)

1 tbsp freshly chopped parsley

Water as needed
(around ¼ cup)

Directions

Drain salmon and sardines, removing all the bones.

Add cottage cheese, turmeric, flaxseed oil and water to get a nice malleable consistency.

Chill mixture for at least one hour.

Shape fish mixture into bite size log shapes and roll in fibre and parsley.

Store extras in fridge in an airtight container for up to 3 days.

Lentils and Ham Hock Stew

Ingredients

1½ cups dry lentils

½ a sweet potato

½ a pumpkin

4 celery sticks

1 zucchini

2 carrots

1 ham hock

4 cups water

2 tsp beef stock powder

Directions

Heat oven to 180°C/350°F.

Put all ingredients into the pot, use a chasseur or similar.

Cook for 4 hours.

After 2 hours check the water has not dried out, if so add more.

Cool to room temperature and serve.

Freeze left overs, or keep in the fridge for up to 3 days.

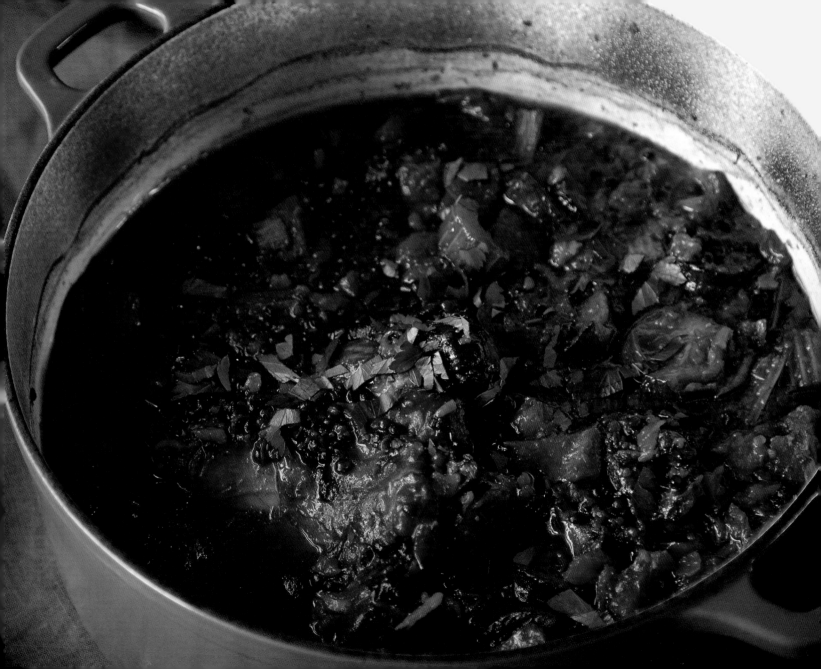

Puppy Paella

Ingredients

3 cups low salt chicken stock

2 cups water

500g/17 oz minced beef

4 chicken thigh fillets, cut into 3cm/1 in. pieces

2 cups medium grain brown rice

1 ripe tomato, finely chopped

1 cup frozen peas

2 tsp turmeric

1 carrot, finely chopped

Celery (optional)

Directions

Put stock and water into medium saucepan and bring to boil.

In a large fry pan, cook chicken and mince over medium heat.

Add carrots. Cook for an extra 3 minutes.

Remove mixture and place in a bowl.

Turn down the heat to medium low. Add rice, turmeric and tomato. Stir for 1 minute, or until combined.

Add ⅓ of stock, and stir until combined.

Add chicken and vegetable mixture. Simmer until almost absorbed.

Add remaining stock and cook until stock is absorbed.

Sprinkle with peas and remove from heat.

Leave until it has cooled to room temperature.

Store extras in fridge in an airtight container for up to 3 days.

Turmeric Kibble

Ingredients

3 tbsp turmeric

6 cups oat flour (processed oats)

3 cups rolled oats

1½ cups cooked brown rice (I use a 250g packet of 90 second brown rice)

1½ cups pearl barley, millet, quinoa, or split pea

6 eggs

1-2 cups water

Additional water as needed

A mix of vegetables, pureed (carrots, beans, peas, sweet potato, pumpkin)

500g/17 oz minced meat, cooked

2 big stalks fresh rosemary, remove the stalk

2 tsp powdered beef stock powder

2 tbsp linseed meal

3 tbsp sunflower oil

½ cup brewers yeast

Directions

Combine dry ingredients—cooked brown rice, pearl barley, quinoa, or split peas (whichever you choose to use)—in a large bowl and mix together well.

Add the cooked meat and vegetables to a food processor and mince.

Add the eggs and with your hands, mix all of the ingredients together.

Pour mixture into 3 or 4 baking trays. Spread so it is about 3 cm (1 in.) thick.

Cook for 45 minutes at 180°C/350°F.

Cut in to small bite sized pieces when cool and serve.

Freeze left overs, or keep in the fridge for up to 3 days.

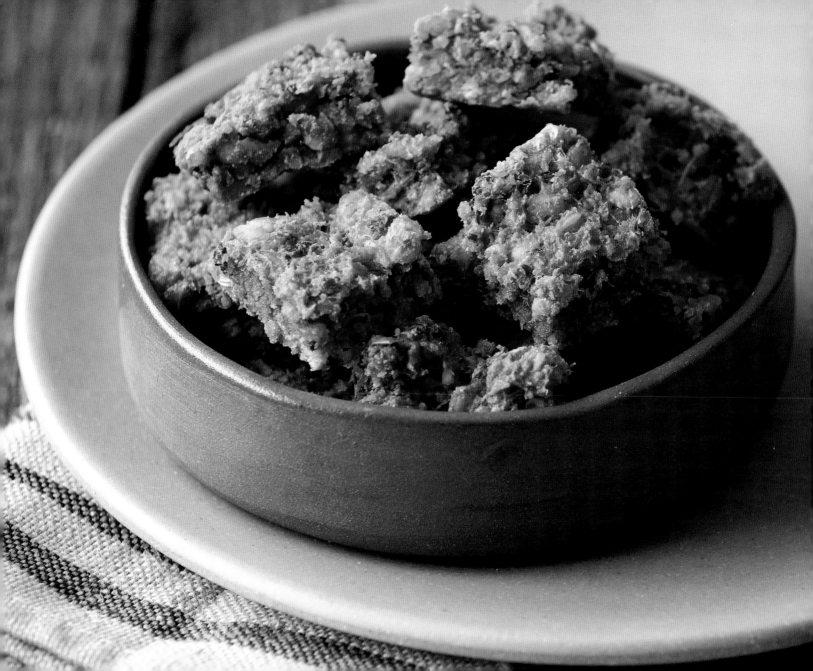

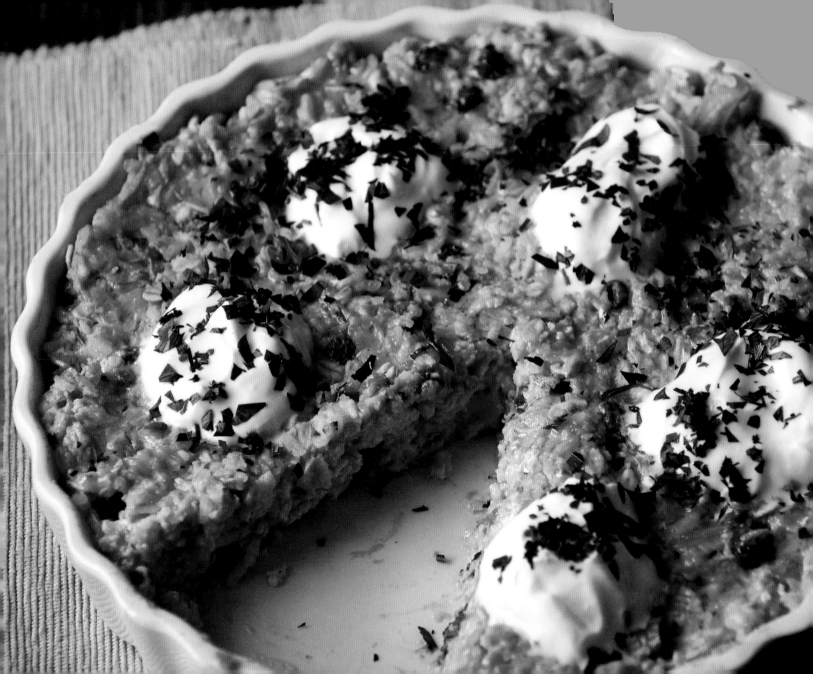

Bear's Chicken and Rice Special

Ingredients

½ cup brown rice

¼ cup Arborio rice

1 cup oats

7 cups water

500g/17 oz chicken mince

300g/10 oz liver, finely chopped (optional)

1 carrot, grated

1 zucchini/courgette, grated

½ broccoli

½ cup frozen peas

½ cup semolina

(You can also add pumpkin and sweet potato)

Yoghurt and parsley for garnishing

Directions

Add brown rice to a large pot with 6 cups of water and boil for 30 minutes.

Add Arborio rice and another cup of water, and cook for a further 15 minutes.

Add oats and cook for a further 5 minutes.

Add mince and vegetables and cook for a further 15 minutes.

Stir through semolina. Keep stirring until the consistency is thick and all the liquid has evaporated.

Remove from the heat and poor into a dish or tray.

Leave to cool and set.

Garnish with yoghurt and parsley.

Cut and serve.

Store extras in fridge in an airtight container for up to 3 days.

Special
Occasions

Peanut Butter Tea Cake

Ingredients

2 eggs

¼ cup peanut butter

1 carrot, grated

¼ cup cooking oil

1 tsp vanilla extract

⅓ cup honey

1 cup whole wheat flour

1 tsp baking powder

½ cup lactose free milk

Directions

Preheat oven to 175°C/350°F.

Grease a cake tin.

In a bowl, combine and blend all the ingredients, except the carrots. Fold through the carrots at the end.

Add mixture to cake tin.

Cook for 30 minutes or until golden on top.

Store extras in an airtight container for up to 3 days.

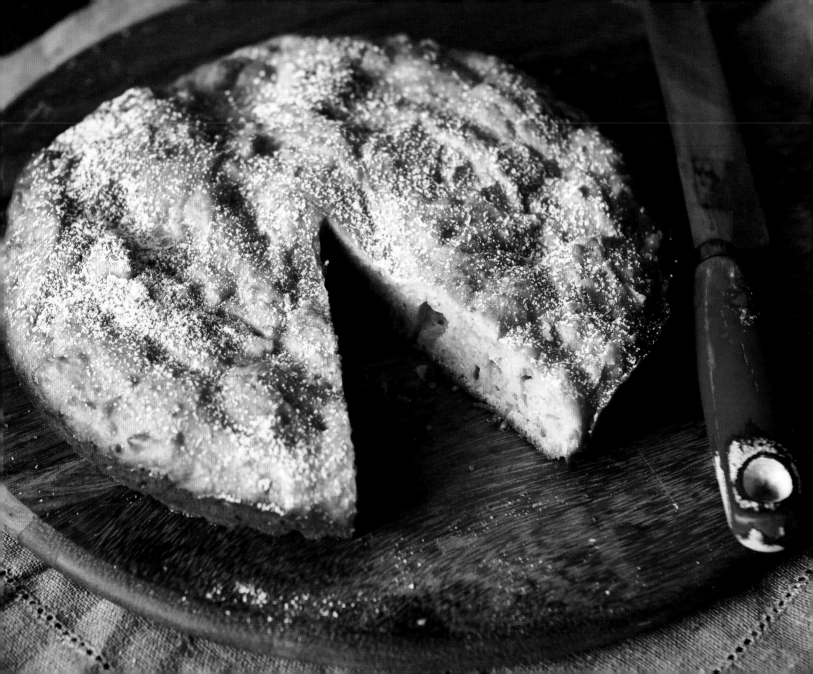

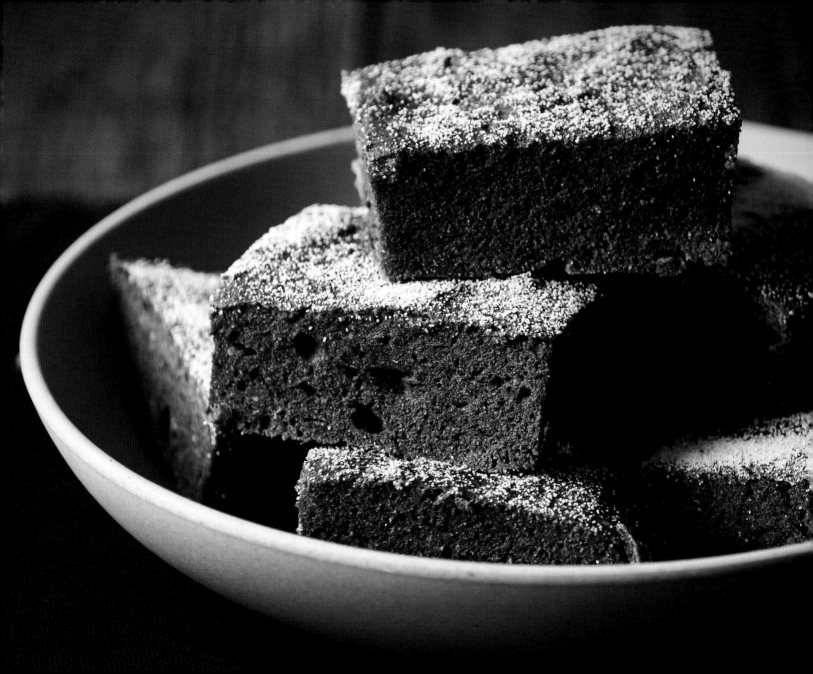

Bow Wow Brownies

Ingredients

1kg/2 lb 3 oz of liver
(beef or chicken)

1 cup rice flour

2 cups coconut flour

½ cup semolina

Directions

Preheat oven to 200°C/390°F.

Grease a baking tray.

Process liver in food processor or blender, until smooth.

Pour into large mixing bowl and blend in the rest of the ingredients.

Spread evenly onto baking sheet and sprinkle lightly with semolina.

Bake for 30 minutes or until brown and leave in oven to cool.

Cut into pieces and serve.

These brownies will only last 2 days so freeze any leftovers.

Puppy Party Cake

Ingredients

⅔ cup ripe mashed bananas

¼ cup 100% pure maple syrup

¾ cup sunflower oil

3 large eggs

¼ cup water

2 cups rice flour

2 tsp baking powder

1 tsp cinnamon

Chia seeds (for garnish)

Directions

Preheat oven to 180°C/350°F.

In mixing bowl, beat together mashed banana cinnamon and oil.

Add eggs and water. Beat well.

Stir in dry ingredients. Beat until smooth.

Pour mixture into greased cake tin.

Bake for about 30–35 minutes or until cake starts to turn golden on top.

Cool on wire.

Once cake is cool, remove from tin and add frosting.

Optional Frosting
In food processor, blend cottage cheese and vanilla yoghurt. Spread on cake.

Sprinkle with Chia seeds.

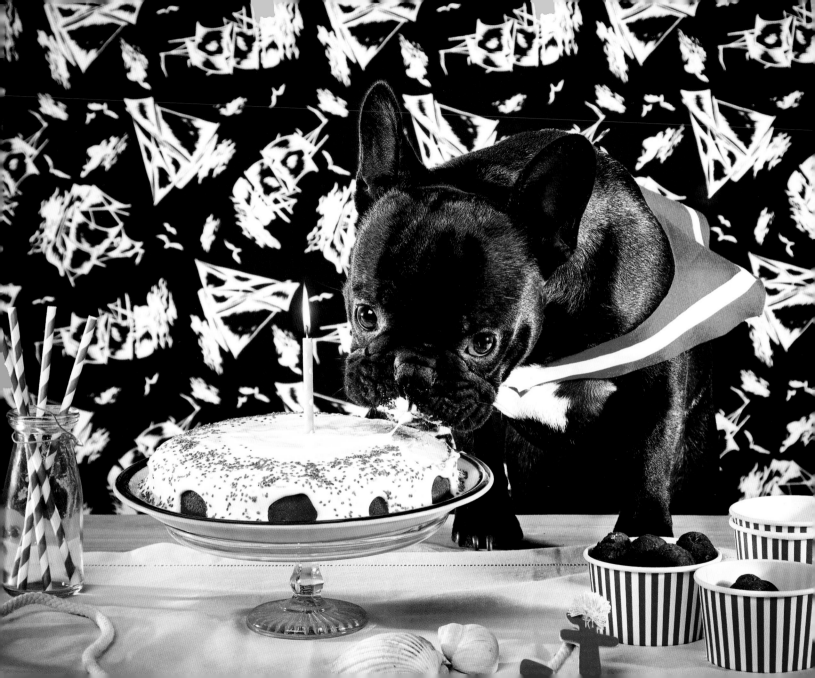

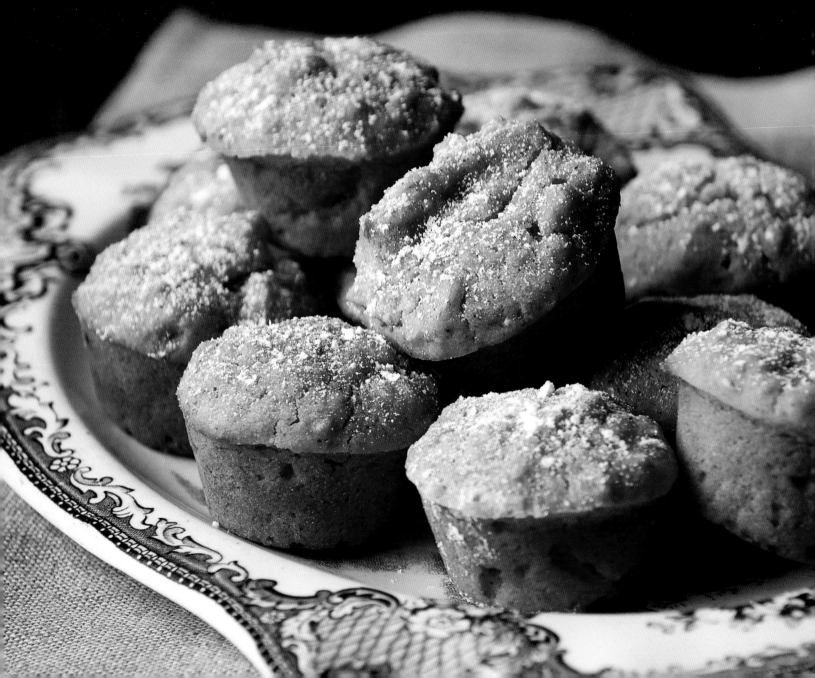

Pumpkin Pupcakes

Ingredients

1½ cups rice flour

1 cup rolled oats

⅓ cup 100% pure maple syrup

2 tbsp milk powder

1 tbsp baking powder

1 ½ tsp ground cinnamon

1 cup pumpkin puree

¾ cup water

⅓ cup sunflower oil

1 egg

Directions

Preheat oven to 180°C/350°F.

Combine flour, oats, milk powder, baking powder and cinnamon.

Make a well in the centre of the mixture and add the pumpkin, water, oil, maple syrup and egg. Stir to combine.

Spoon into nonstick cupcake tins.

Bake for about 25 minutes or until golden brown.

Store in an airtight container for up to 5 days.

Red Velvet Pupcakes

Ingredients

¼ cup sunflower oil

¼ cup 100% pure maple syrup

¾ cup apple sauce

2 beetroots

2 eggs

1 ½ cups rice flour

2 tsp baking powder

Directions

Preheat oven to 180°C/350°F.

Peel and steam 2 beetroots. Put in blender or food and puree.

In a large bowl whisk together the egg, oil and sugar. Stir in apple sauce and beetroot puree.

Combine flour and baking powder in a separate bowl.

Mix dry and wet ingredients together.

Spoon into lightly greased cupcake tins. Bake for about 30 minutes or until cooked through.

Frosting
1 cup low-fat cottage cheese (pureed to remove lumps), or low-fat natural yoghurt.

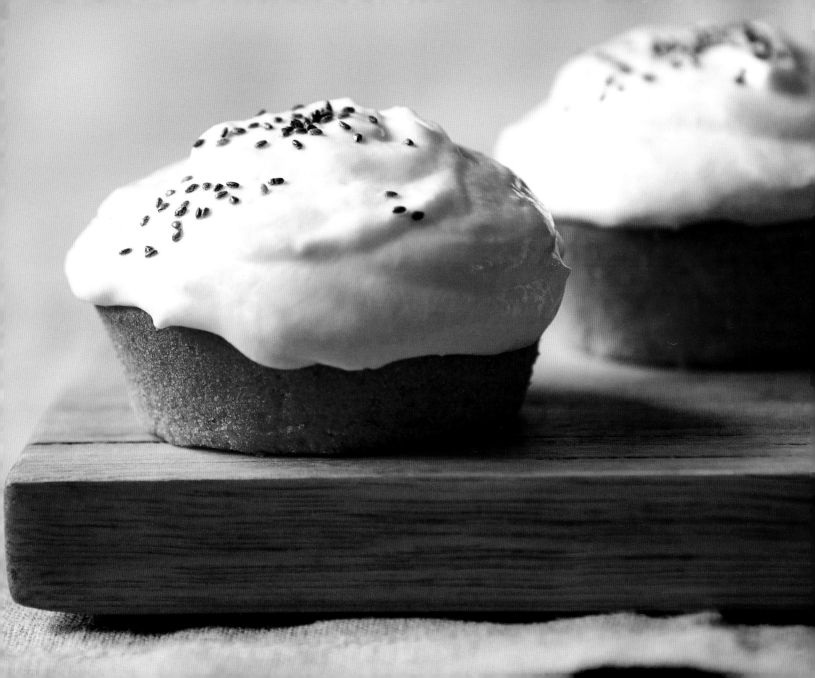

Apple and Zucchini Pupcakes

Ingredients

1 large apple

1 zucchini/courgette

1½ cups flour (gluten free)

¼ cup oats

2 tsp baking powder

½ cup plain yoghurt

½ cup water

¼ cup sunflower oil

¼ cup 100% maple syrup

2 eggs

Directions

Preheat oven to 180°C/350°F.

Core and finely chop the apple.

Grate the zucchini/courgette.

Mix together flour, oats, and baking powder.

In a separate bowl, blend together the yoghurt, water, oil, maple syrup and eggs and fold in the apple and zucchini/courgette.

Add wet mix to the dry ingredients.

Spoon into cupcake tins.

Bake for about 20 minutes or until firm.

Leave to cool and serve.

Store in an airtight container for up to 3 days.

Baked Custard and Blueberries

Ingredients

1 cup blueberries

3 eggs

1 tsp vanilla essence

¼ cup coconut flour

1½ cups lactose free milk

¼ tsp cinnamon

Directions

Heat oven to 180°C/350°F.

Blend together everything, except for the blueberries.

Pour into 3 ramekins.

Bake in oven for 10 minutes.

Remove ramekins from oven and drop blueberries over the top.

Put back in oven until golden brown.

Let cool and serve.

Store in fridge in airtight container for up to 3 days.

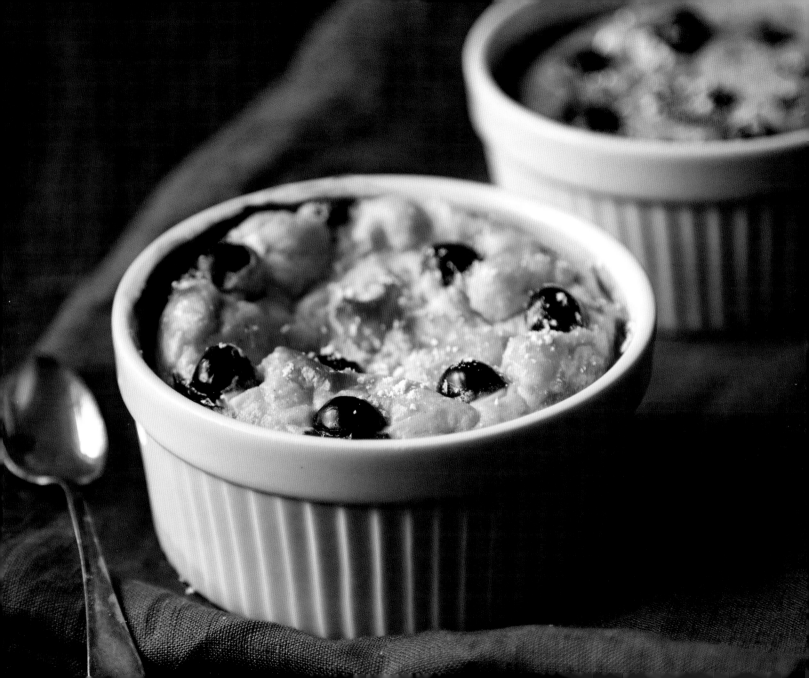

Animal SOS Sri Lanka

About the Charity

Animal SOS Sri Lanka (ASOS) is a charity dedicated to alleviating the suffering of street animals in Sri Lanka.

The charity was founded by Kim Cooling, a British woman who had visited the island as a tourist and was moved by the heartbreaking plight of stray animals.

ASOS has a no-kill 4-acre free-roaming animal sanctuary in the south of the island that offers refuge and lifesaving veterinary care to sick and injured strays, as well as rehabilitation, adoption schemes, and local feeding programs for starving strays. There are currently over 700 destitute cats and dogs in their care, many nursed back to health from serious diseases and horrific injuries.

The charity is operational 365 days a year, has an on-site veterinary clinic and employs a resident vet as well as other local staff to help care for the animals. ASOS provides weekly outreach programs in the local villages where they conduct health checks, sterilise and vaccinate cats and dogs against rabies, provide worming and other anti-parasitic treatments, treat wounds, infections and skin conditions. ASOS also provide animal welfare educational materials and give out collars and leads to prevent painful neck injuries caused by tethering with ropes and wire.

This charitable work benefits both humans and animals, creating a better and healthier environment for all. They provide local employment opportunities and reduce the risk of rabies and animal suffering through weekly vaccination and sterilisation programs. Every cat and dog that is sterilised helps to prevent unwanted litters born to a miserable existence and premature death. ASOS feeds around 800 animals every day and the running costs are mounting. They desperately need help to continue this work.

www.animalsos-sl.com

'This is a fantastic charity and one I will be supporting through the sales of this book both in raising awareness and making a financial donation at the end of 2015'

—Asia Upward

Meet the Models

Bruce

Great Dane

Chief

Aussie x British Bulldog

Ryker

Bullmastiff

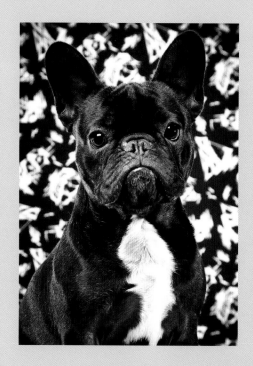

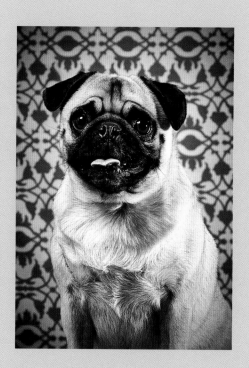

Frenchie

French Bulldog

Gus

Schnauzer

Wilma

Pug

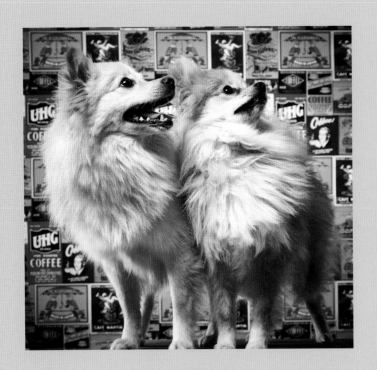

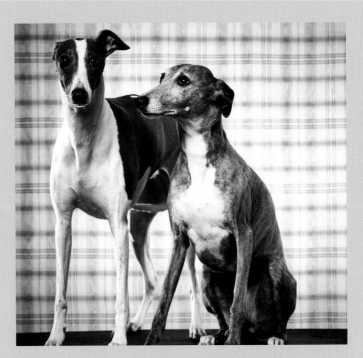

Kirra & Kye

Pomeranians

Twiggy & Yoko

Whippets

Atlas

Tibelan Mastiff

Shae

Saint bernard

Boston

Great Dane

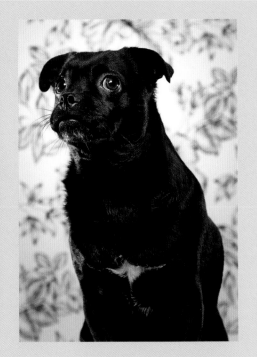

Gus

Chihuahua

Pepper

Chihuahua

Bindi

Pug x Jack Russell

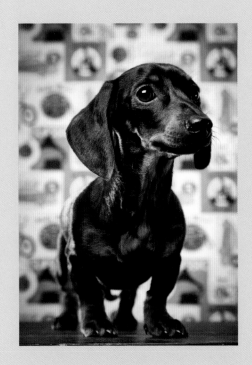

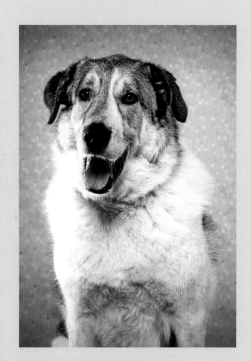

Heidi

Daschund

Ellah

American Hairless Terrier

Sascha

Anatolian Shepherd

A DOG'S WORLD

Homemade recipes for your precious pooch

Important disclaimer
It is recommended you always consult your vet on dietary requirements for your particular dog, as these recipes may not provide the correct nutrients they need.

Please never serve your dogs hot food straight out of the oven. Always allow it to cool to room temperature before serving.

Acknowledgements
I would like to thank the following for their contributions to the book. All the dog owners: Stephanie Fletcher-Smith, Karlee Fletcher-Smith, Danielle Gal-Schilz, Stacey Barlow, Sasha Myer, Quinlan Nguyen, Samuel Winship, Hannah Thiel, Aleisha Pattinson, Megan Paape, Kimi Lee, Lorraine Konias, Peter Dihm, Magi Hollis, Jasmin Briscoe, Colleen Burke, Nadine Kiss, Brian Kelly.

My dog, Bear, who has inspired me to do this book and has offered his time as a recipe tester.

A big thank you to my stepson Eddie Rigney, for being the only human model featured in the book. Last but not least my husband Thom Rigney, who has supported me on this project from the very beginning.

Credits
Photography and recipes: Asia Upward
Retoucher: Dave Mercer

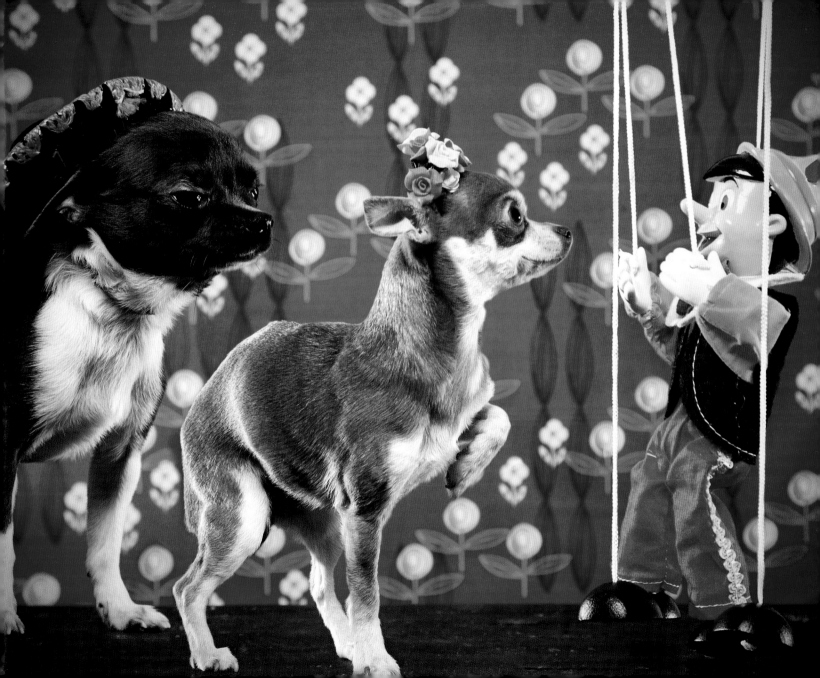

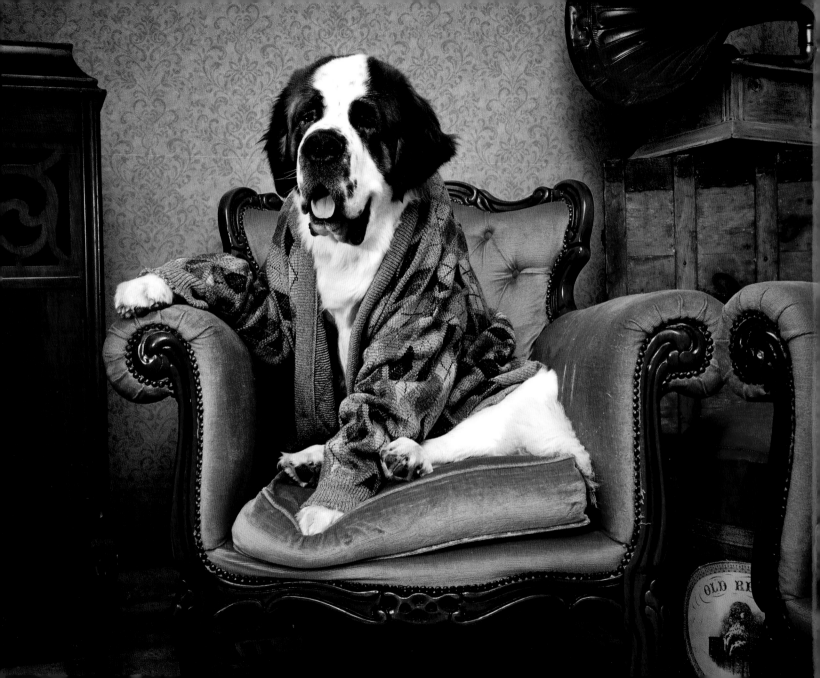

Index